A SCHOOL WITHOUT ART

I am math,

I am science; I'm history too.

I am English and Poetry;

I'm the dance, I'm the music,

I give you rhythm and beats:

I AM ART!!!

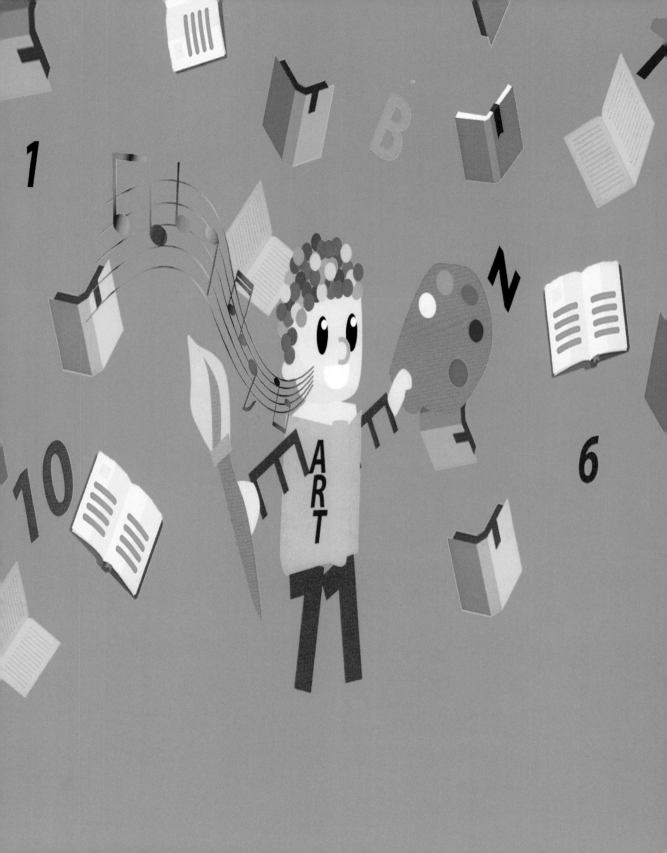

I am comprised of all the core subjects that you cannot create without me.

Sometimes I feel sad because I am not appreciated at all. Schools put me out because they say we don't need ART anymore; so I watch as creativity slowly fades away and withdraws.

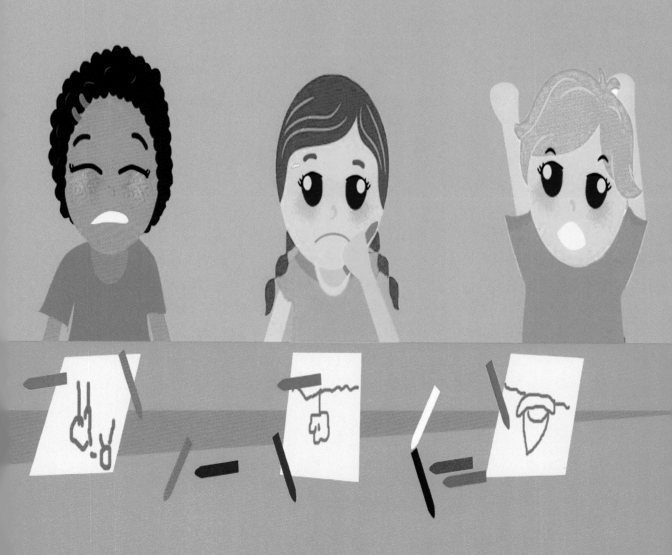

The faces of children turned sad as all the colors of Crayola and paints faded away. The grown-ups forgot that Art had made them dream, become creative, and inspired them too.

Everyone had forgotten that Math is an absolute, and cannot be changed at all: Math's friends are merely numbers, and numbers is all they will ever be. They forgot that Science likes to try turning what is a simple hypothesis into a fact: now how do you like that?

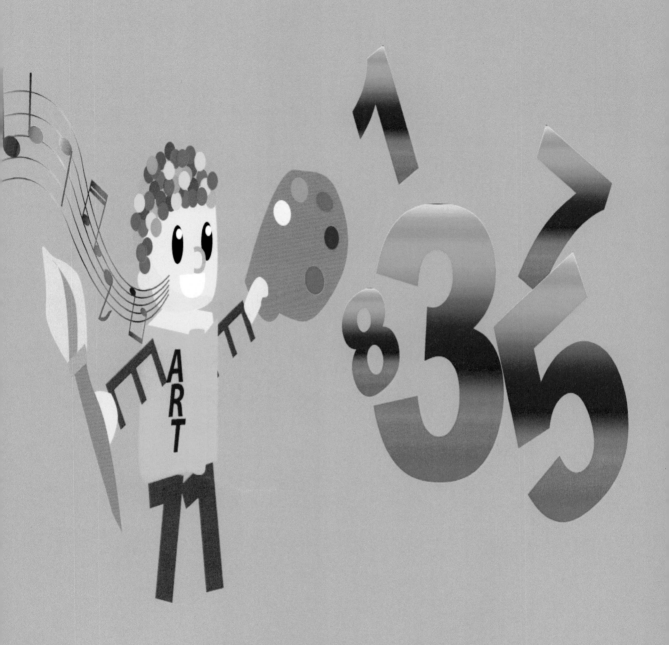

Yes, ART was special. He was also a playmate and friend to them all; despite how they treated him because of what they all thought were all type of flaws. They said he was messy and all over the place. He was never consistent; he split, and he splattered: sometimes at recess he made beats on the strangest objects, and made a sort of music that everyone thought strange. Art speaks with a flow, and then he speaks in rhymes, he speaks like a poet with words that cannot be defined.

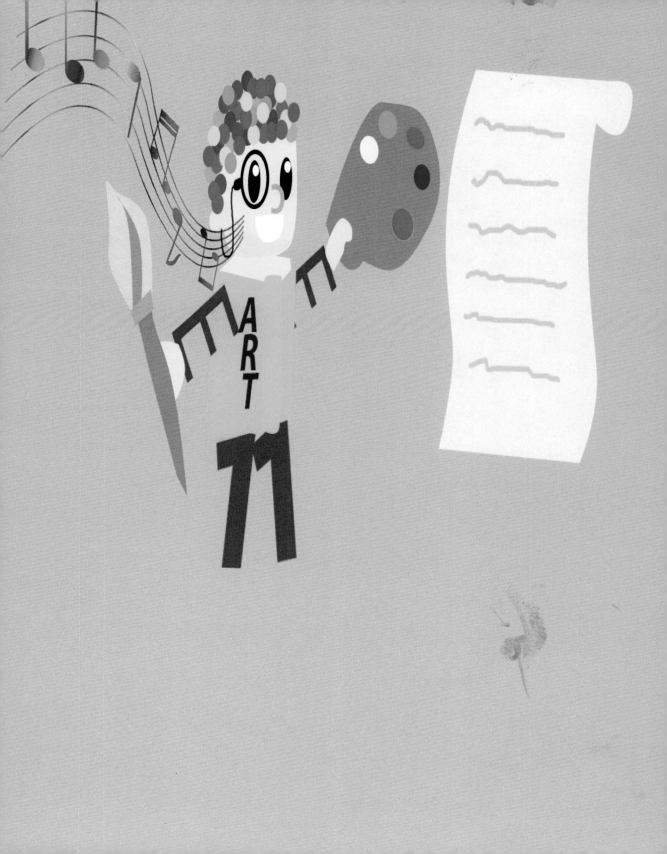

Because they all thought Art was strange they asked him to leave. Art did what they asked, but soon everyone realized that school-life without Art wasn't the same. They soon realized that without Art, the school had a dark gloom.

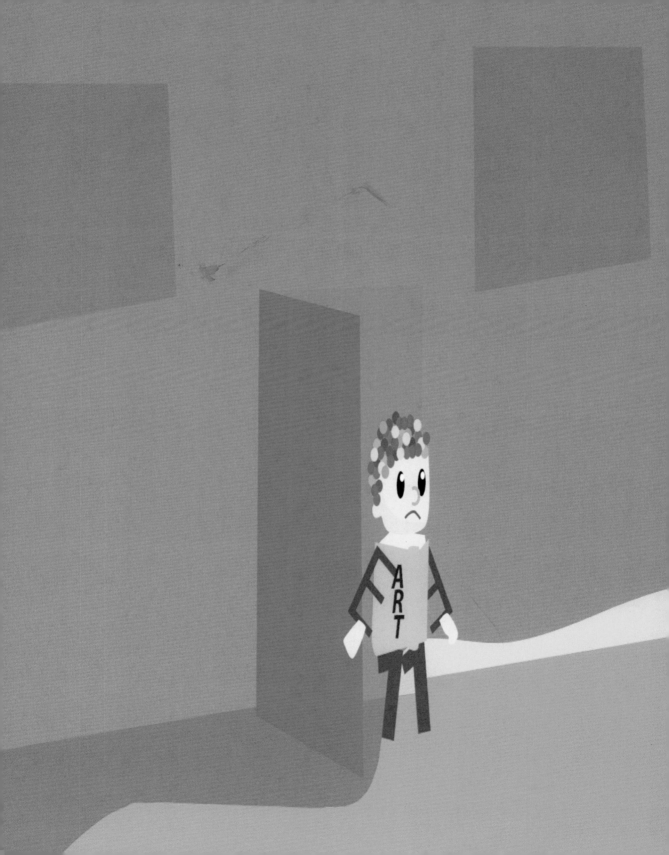

They realized that though Art looked funny and had strange ways; he always seemed to be disorganized and was all over the place: But ART added excitement to learning and sparked a flame in everyone's brain. Art gave them a reason to laugh, to cry, to feel, and to play: To be bubbly, and creative in their own special way. So, the teachers, the students, and the principal too; they all went to Arts house and knocked on the door.

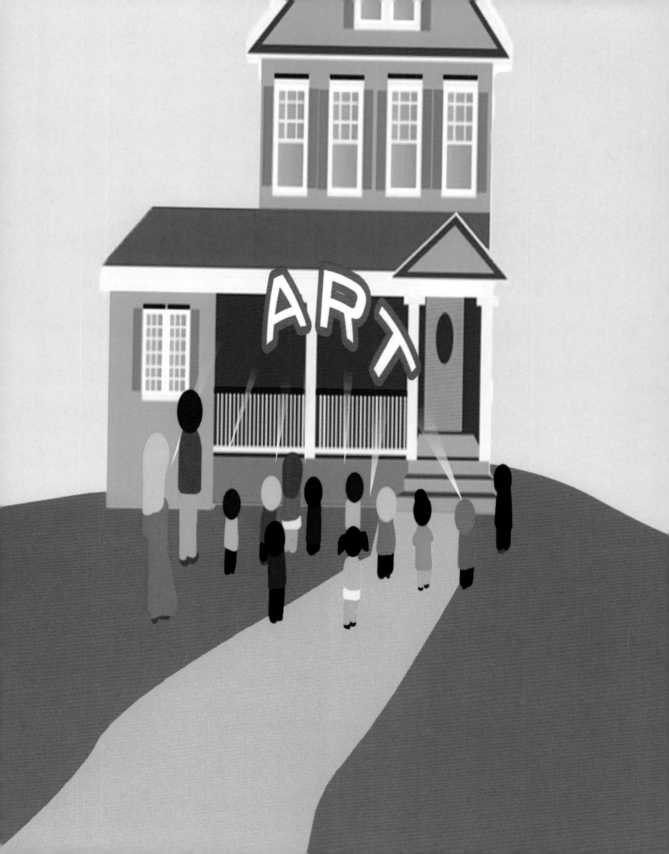

Is Art home? They all asked with a scream! Art's mom said, "Yes, Art is here. He is in his room creating videos and graphics, Virtual reality too. He is creating something new, something fresh, something alive to add to the world and help the economy thrive". Art's mom called his name, and said "honey come here". As Art ran downstairs, and came to the door, they all said, "Art please forgive us; will you please come back to school and help us grow"? Art said, **"Yes"** with excitement and a happy smile on his face.

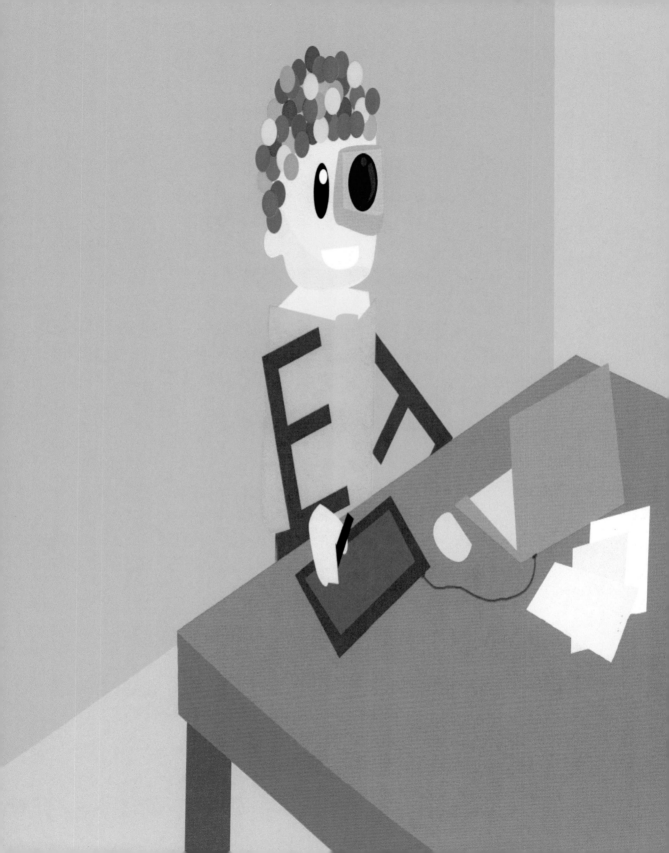

Monday morning, Art walked into the school. The moment he entered he heard cheering and saw a big sign that read, **ART, WELCOME BACK!!!**

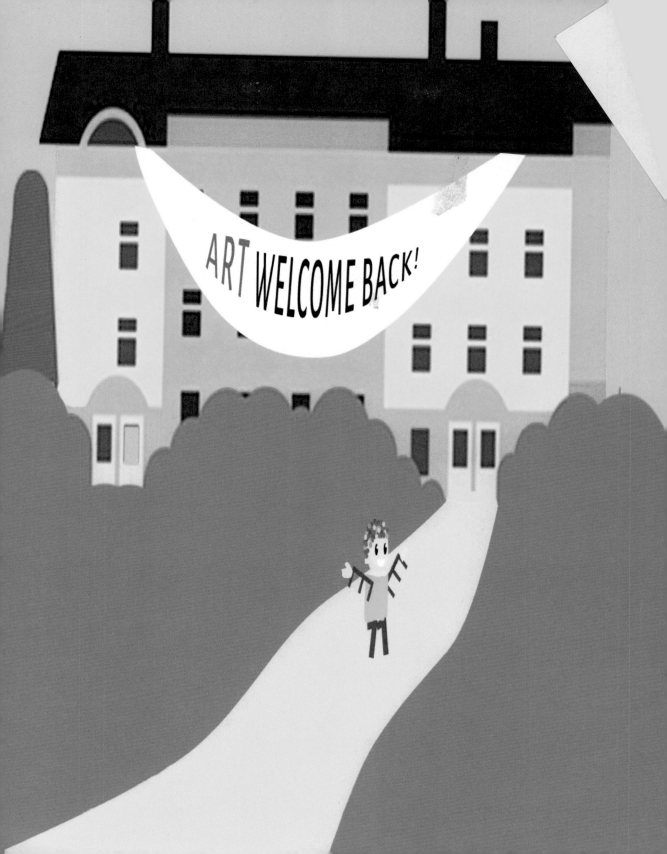

Everyone looked through the school's window and saw that something strange and wonderful had happed. A rainbow had suddenly appeared in the sky. The school seemed to come back to life; and the dark feeling of gloom and negativity was erased. Art had made learning fun again!!!

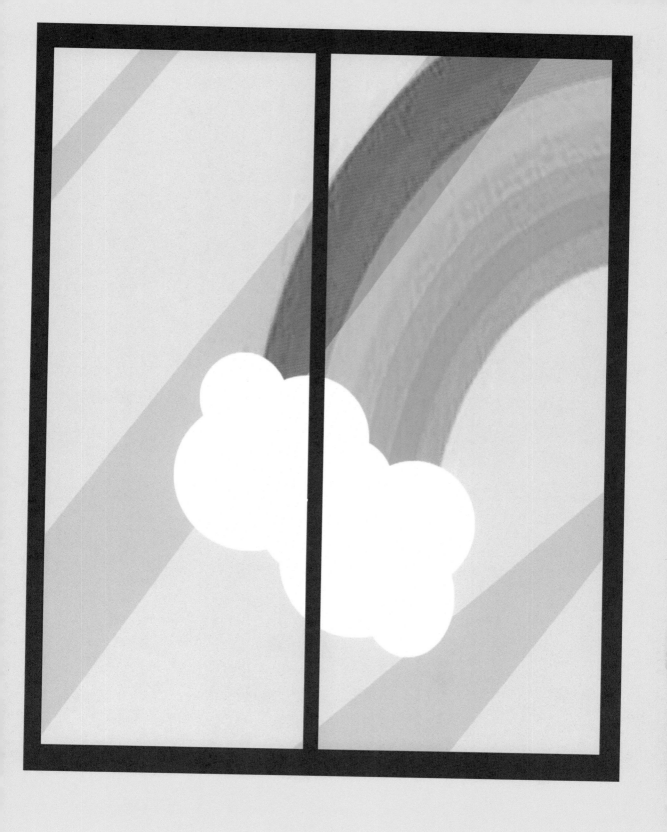

This book was written to show the importance of art and creativity. I hope it shows how art and core subjects go hand-in-hand to inspire and create a complete and well-rounded person.